Smiling Sushi Roll

by Tama-chan

TUTTLE Publishing

Tokyo | Rutland, Vermont | Singapore

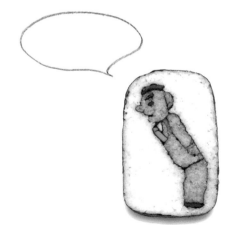

 Prologue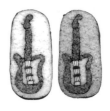

Everyday life is full of hidden surprises that are waiting to be discovered. I like to develop my own original style by working with images people are familiar with so that they'll see something new in the things they already know.

Japan is a place where you can buy anything in a shop, so though everyone there has eaten a sushi roll, relatively few people (including me, at one time) had ever made one themselves. One day, I saw a sushi roll with a pattern on the surface and thought it would be very interesting to draw "freehand" on that surface. So, I gave it a try.

But when I actually started to make the sushi roll, I found that the pattern on the surface wasn't always what I expected. This was because a pattern's structure depends on the amount of vinegared rice used, the way the ingredients are cut, the layout of the ingredients, the pressure applied when rolling, and so on. I started thinking that this very "uncontrollability" in drawing patterns could actually help me reach my goal.

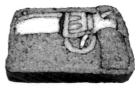

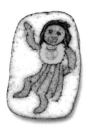
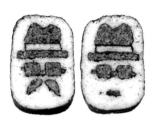

To this day, we enjoy being surprised by unexpected lines and shapes emerging on the cut surface. Then, we enjoy eating it.

To express the joy in this process I named these entertaining sushi rolls the "Smiling Sushi Roll." It carries the message of "making it with a smile, viewing it with a smile, and eating it with a smile."

And as I promote this "edible art" made of rice and seaweed, I intend to keep on challenging common knowledge and conventional ideas.

Tama-chan

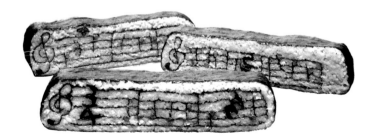

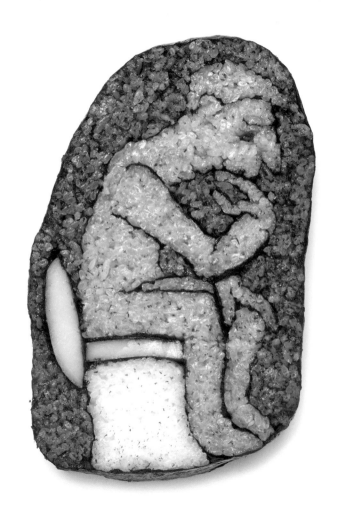

"God helps those who help themselves"

" 神に見放された者は自らの手で運をつかめ "

"The Thinker" by Auguste Rodin

オーギュスト・ロダン「考える人」より

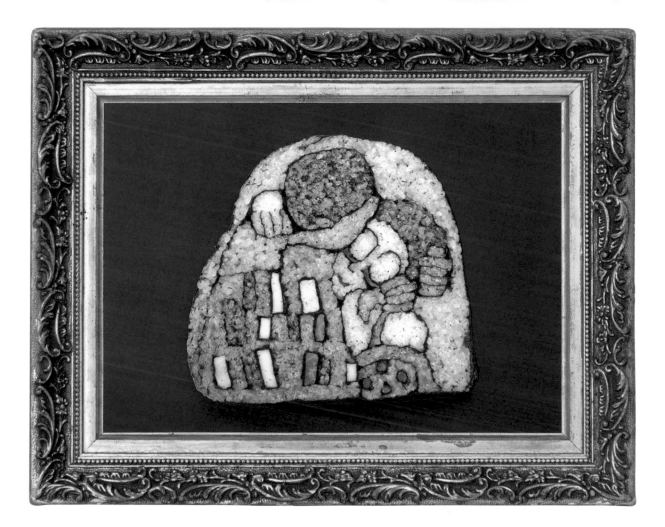

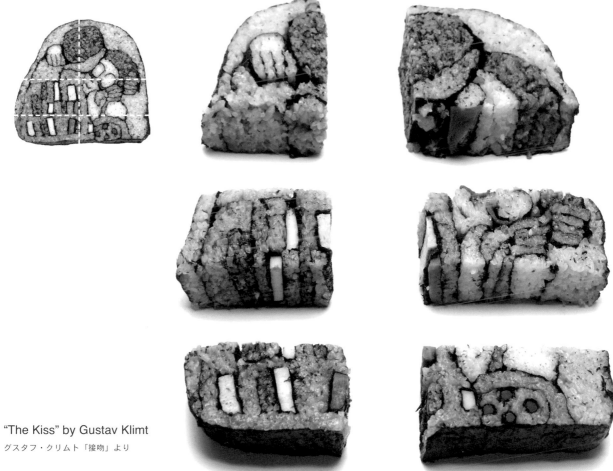

"The Kiss" by Gustav Klimt

グスタフ・クリムト「接吻」より

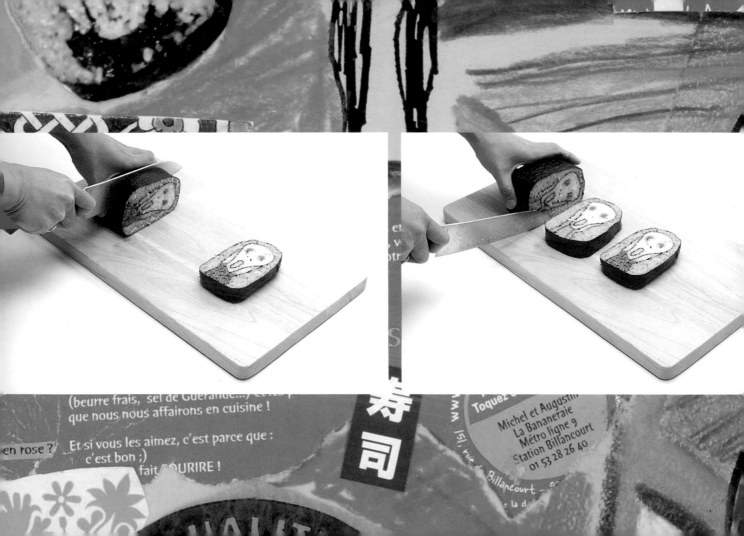

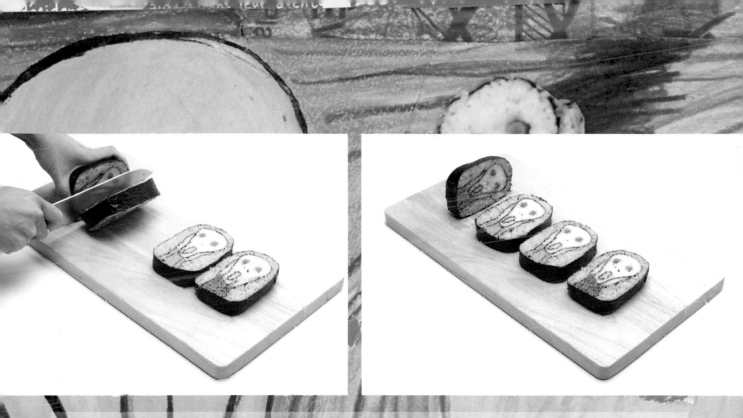

The unique feature of the "Smiling Sushi Roll" is that you see something different each time you cut. The roll sometimes spins a story through changes in color and pattern.

『にっこり寿司』は、一本ののり巻きの中で色が変わったり、動きが加わったりしてストーリーが生まれることも。だから切るたびに驚きは増し、見ている人の歓声は大きくなってゆくのです。

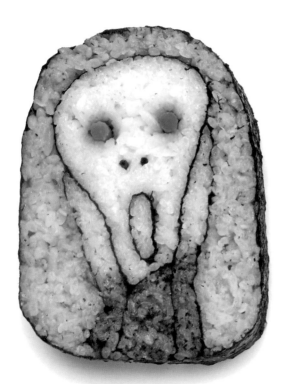
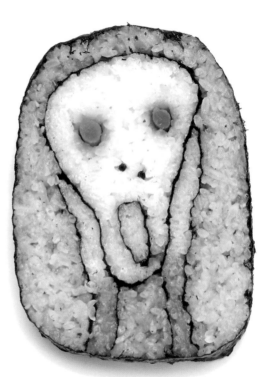

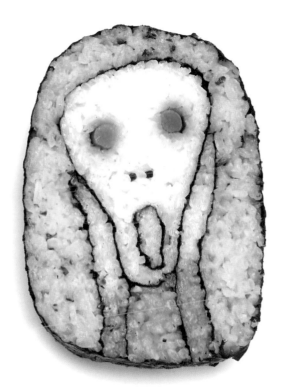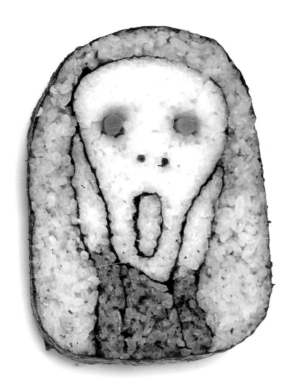

"The Scream" by Edvard Munch

エドヴァルド・ムンク「叫び」より

Memory of My Travels in Spain

This building whose design emerges from the ground almost makes me forget that it's a man-made object.

My sushi roll shapes are sometimes imperfect, but they get praise because "they're not too exact." People have such big hearts!

スペイン旅行の思い出

地面からニョキニョキ生えて来たようなデザインは
人工物であることを忘れてしまいそう。
私の巻き寿司もグニャグニャ、ニョキニョキしているけど
「まっすぐ、キッチリしてないからいい」と言われる。
みんな、心が広いな〜。

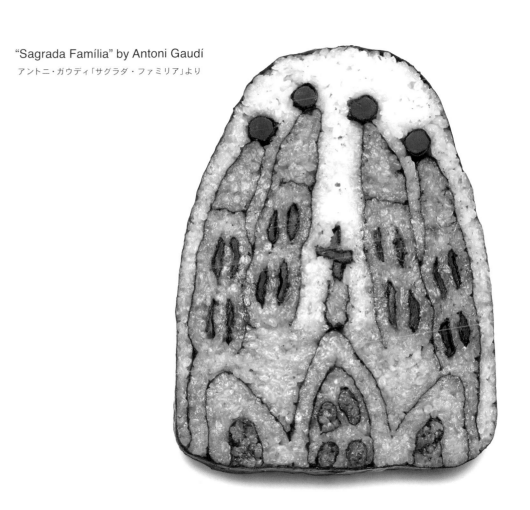

"Sagrada Família" by Antoni Gaudí
アントニ・ガウディ「サグラダ・ファミリア」より

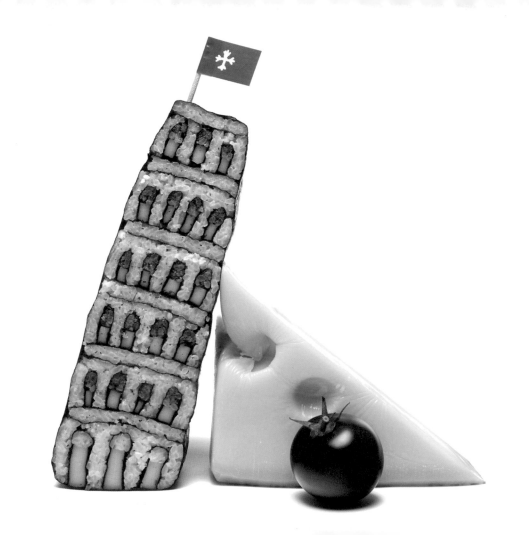

Memory of My Journey in Italy

The Leaning Tower of Pisa became a popular tourist destination because of its slant. It's like that with people too. A quirky person is more attractive than a perfect person who does everything right. Even this tower— its eccentricity kind of makes you want to support it. I supported my leaning tower with cheese. But, I haven't made it to Pisa yet.

イタリア旅行の思い出

ピサの斜塔って傾いたから観光名所になったよね。
人だって何でも出来て完璧な人より、
ちょっとクセがある人に魅力を感じることの方が多い。
この塔だっし、みんな思わず支えたくなっちゃうし。
私はチーズで支えてみました。
あ、ピサには行ったことないけどね。

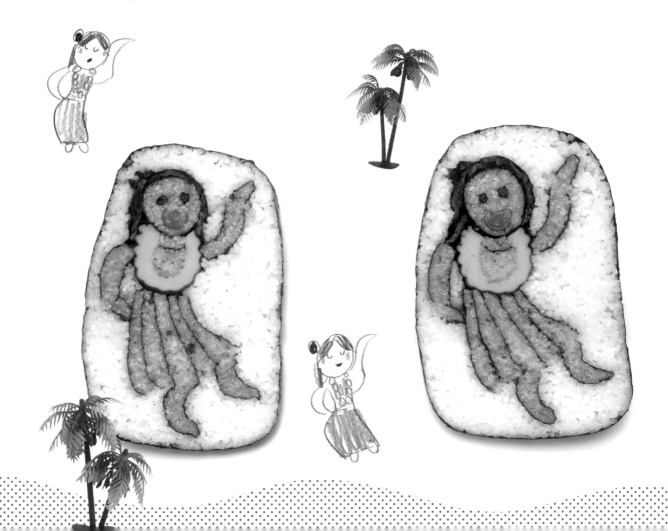

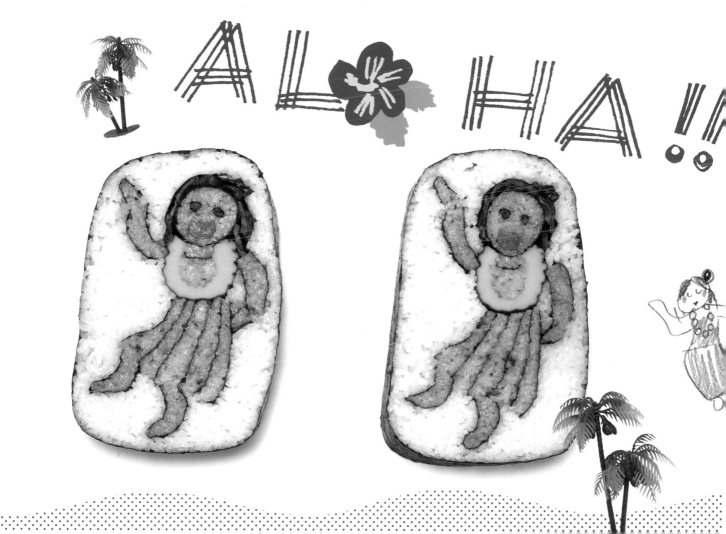

IT IS NOT ONLY A MAN WHO DISGUISES HIMSELF.

変装するのは男だけじゃない。

やまおり Mountain fold

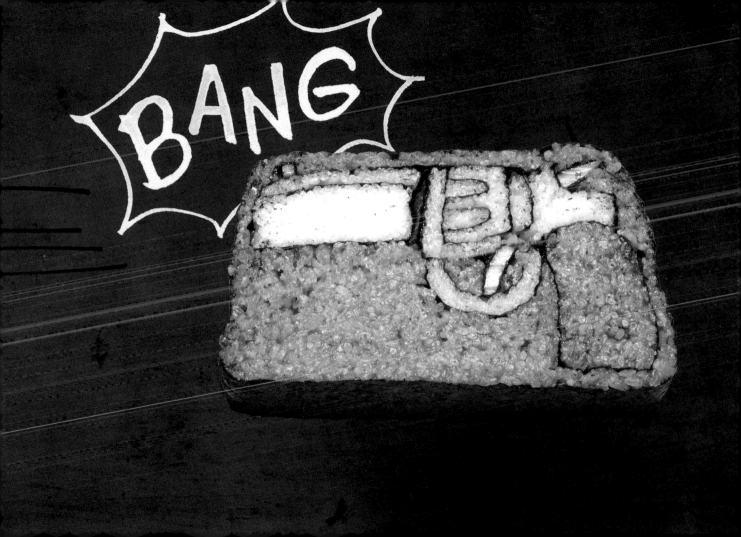

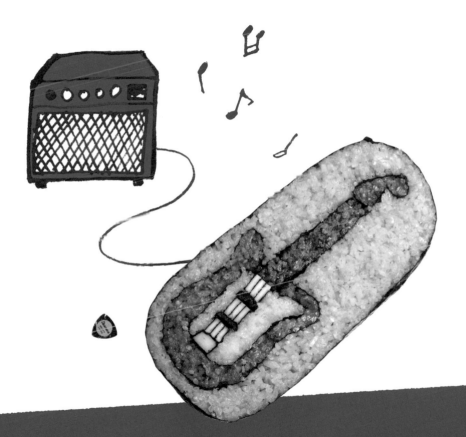

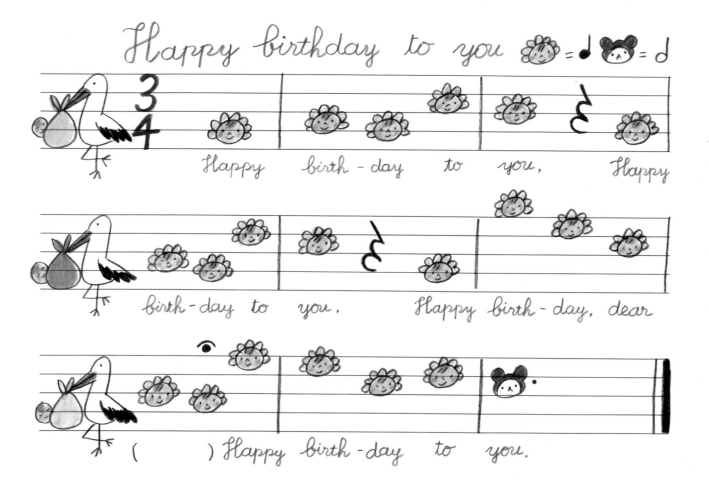

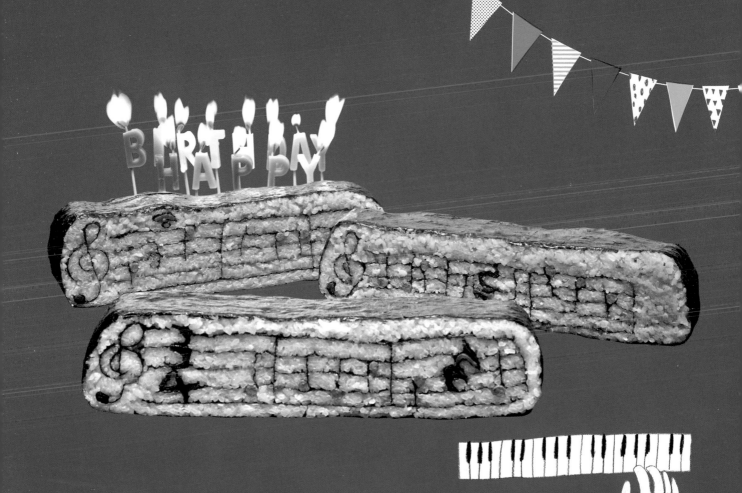

My Japan
私の好きなニッポン

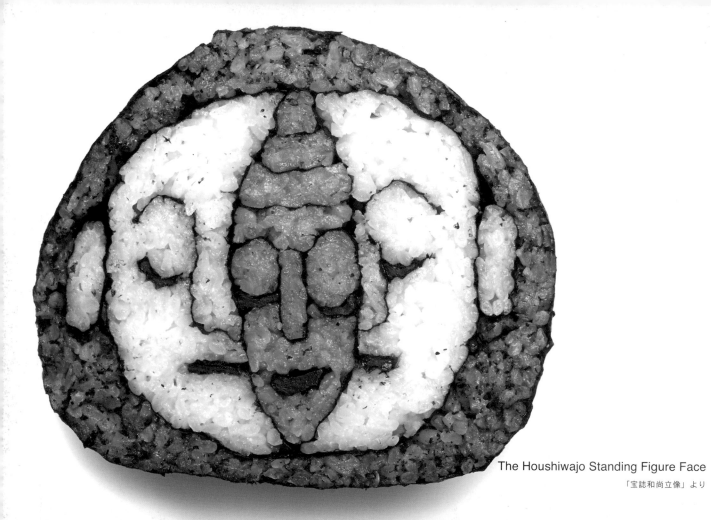

The Houshiwajo Standing Figure Face

「宝誌和尚立像」より

From inside his face...

顔が割れて中から…

The Houshiwajo standing figure can take you by surprise at first. The statue represents the idea that humans are inhabited by gods. So, the face of the figure has a crack, and the Amida Buddha is emerging from it. Houshiwajo was a Chinese monk who had thoughts and ideas beyond those of the ordinary person. His stories have been passed on from generation to generation. Fantastic!

宝誌和尚立像を京都の博物館で初めて見た時、ビックリした。 ふざけている！ いえ、ふざけているわけではなく「人は内面に神仏が宿る」という意味が込められて中から阿弥陀如来が現れているところらしい。 宝誌和尚は風狂の僧で、一休さんのように常人の域を超えた中国の和尚さん。 こんなふうに後世に伝えられるなんて、宝誌和尚っておちゃめな人だったみたい。 ステキだね！

Houshiwajo Standing Figure, property of the Saioji Temple

Rolling rice within rice.

お米をお米で巻いてみた。

The Japanese kanji character for "rice" is *kome* (米).

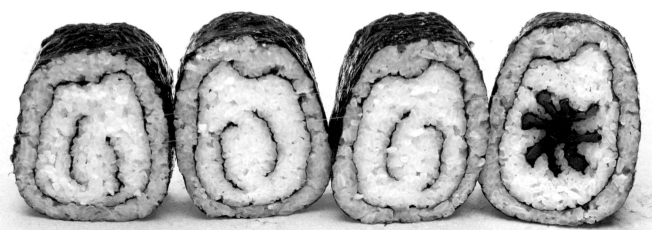

One long roll cut once … … cut twice … . At the end you have the
 Japanese character for "rice."
 That's rice within rice within rice!

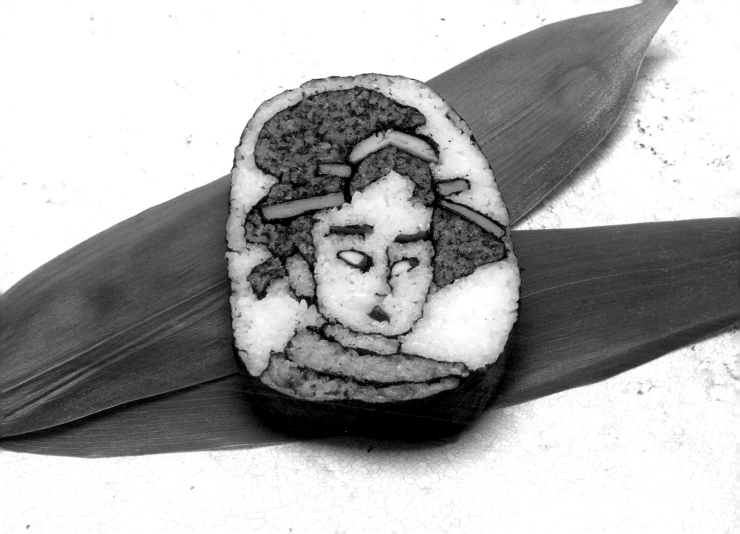

A Longing for the Edo Period

The oirans in ukiyoe paintings and the ninja you see in the movies don't exist anymore. But some people out in the world believe they still do, the way they did in the Edo period. They were the idols and stars of their day. I think the Edo period must have been really cool!

あこがれの江戸時代

浮世絵の中の花魁も映画やドラマに出て来る侍や忍者も今はいない。
でも海外では今でもいると思われていたり。
私達は本物の侍も忍者も花魁も見たことってないけど、
江戸時代には確かに存在した。
アイドルもセレブもスターもいた江戸時代って、
とんでもなく楽しそうだな〜と思う。

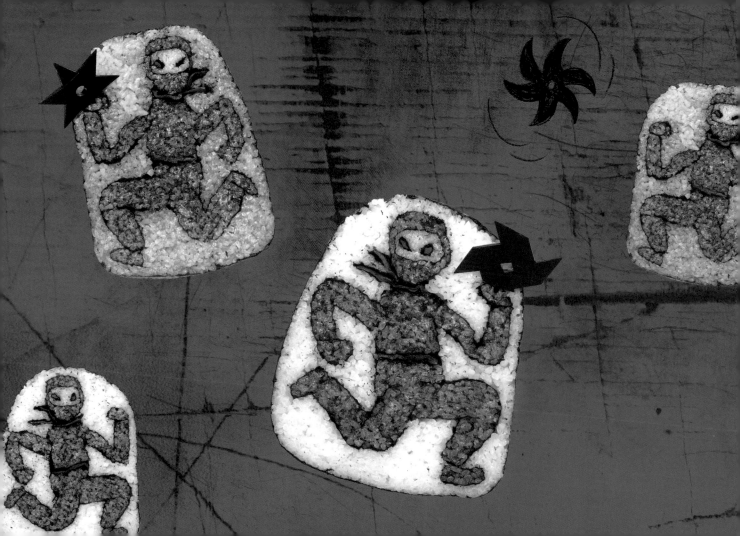

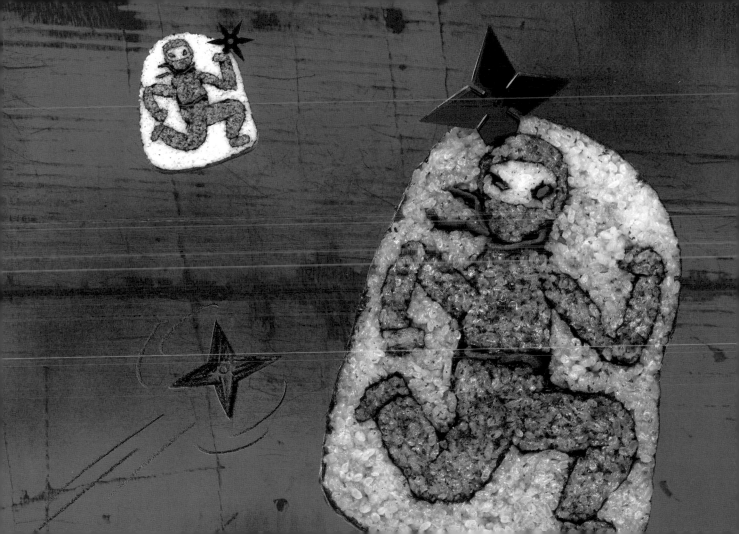

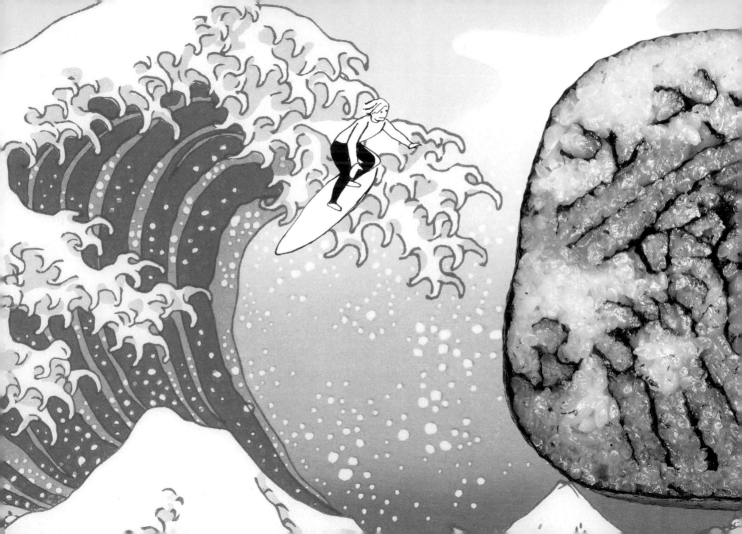

伝説の
BIG WAVE

"The Great Wave off Kanagawa" by Hokusai

葛飾北斎「神奈川沖浪裏」より

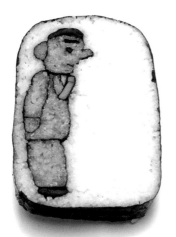
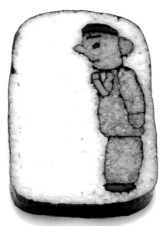

"Nice to meet you."

「はじめまして」

"Nice to meet you too."

「お世話になります」

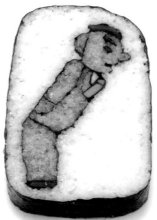
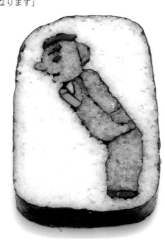

The Japanese Salaryman

ジャパニーズ

サラリーマン

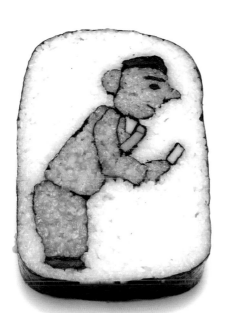

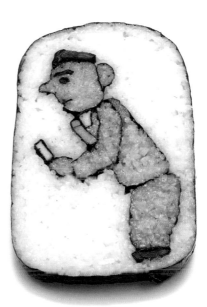

"I'm Yamada working for the
●✕ trading company."

「●✕商事の山田です」

"I'm Tanaka working for the
▲■ corporation."

「▲■物産の田中です」

EROS

エロス

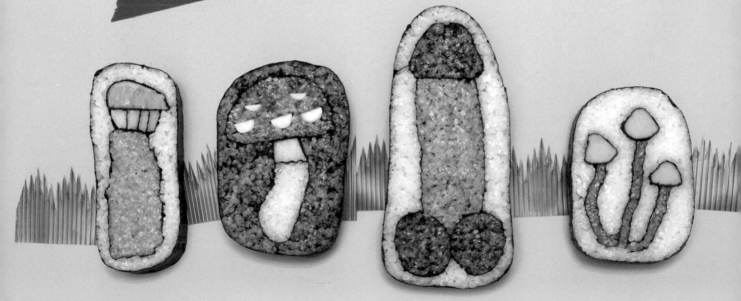

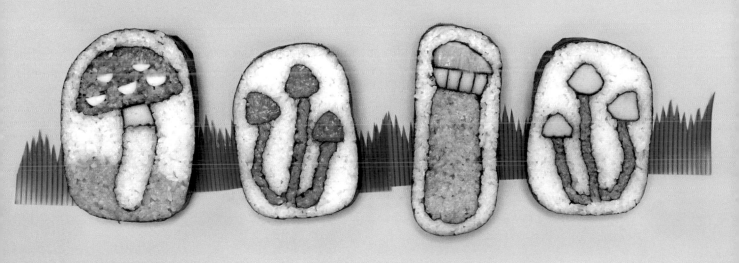

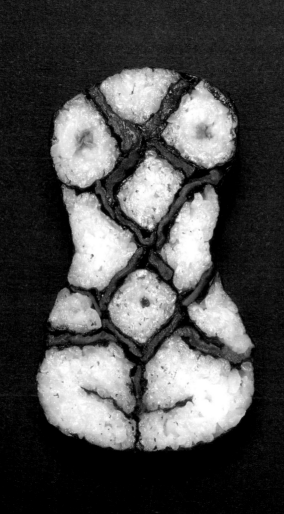

Bondage

During the Edo Period various ways of restraining prisoners were invented. After the Meiji Restoration bondage fetishism came out of the closet, with Japanese aesthetics.

緊縛

江戸時代、囚人の拘束のために様々な縛り方が考えられた。
日本人の美麗を求める感性も加わり、
明治維新以降そこに性的興奮を覚える嗜好が公になったそうだ。
エロと美は人を魅了し続ける。

"Completing Each Other" is a symbol of peace and happiness.

凸凹は、
「愛と平和」の象徴。

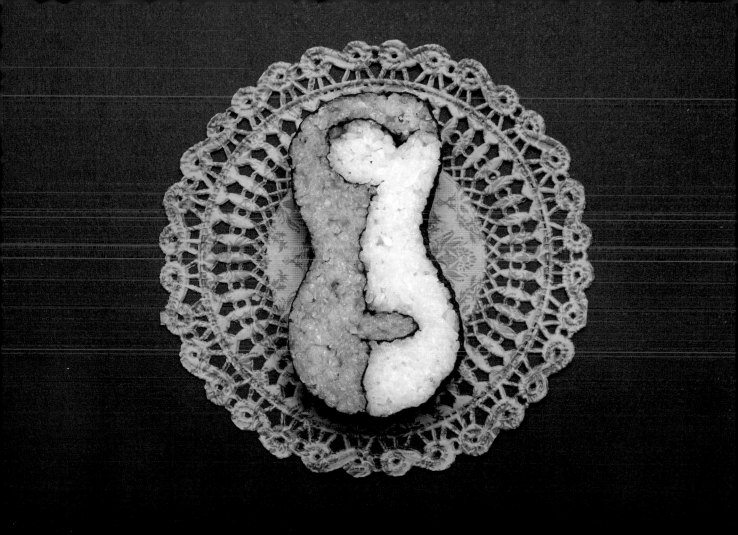

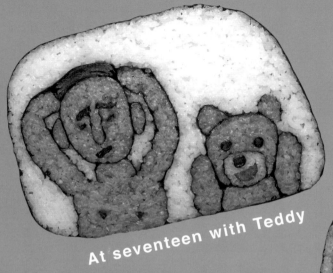

At seventeen with Teddy

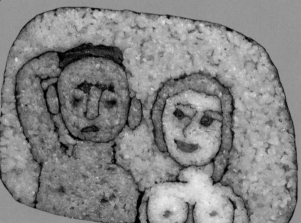

At nineteen with Kathy

Pillow

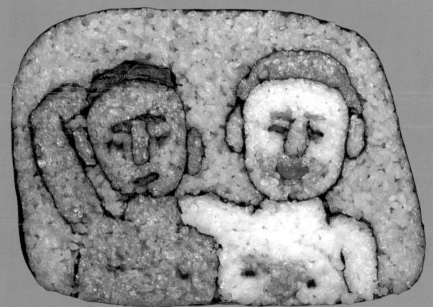

Talk

At thirty with Mike

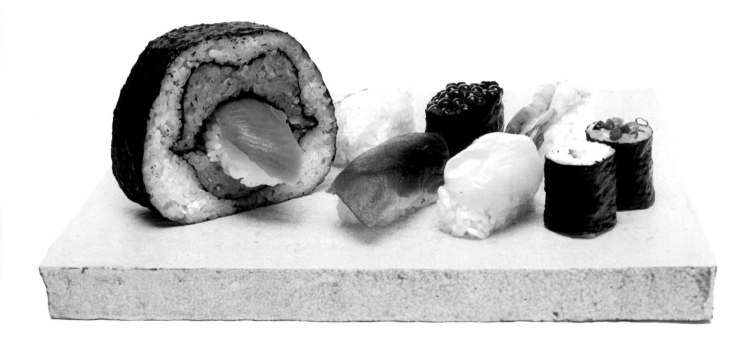

What do you suck?

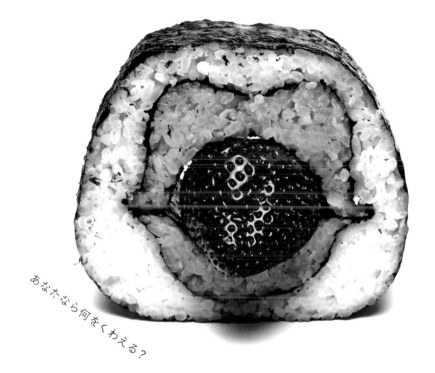

あなたなら何をくわえる？

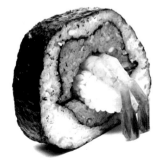

やまおり Mountain fold

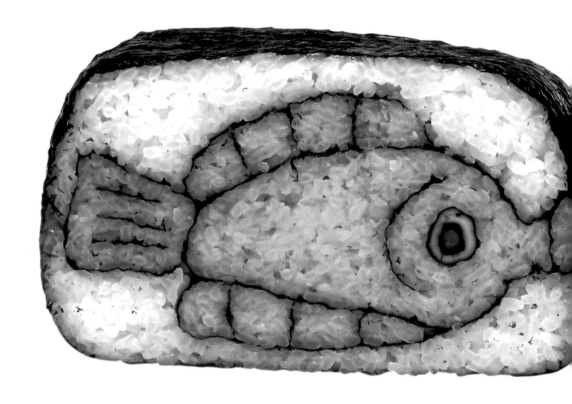

We are not a lovey-dovey couple. Actually,

イチャイチャしているんじゃないんです。2匹は縄張り争いのため、

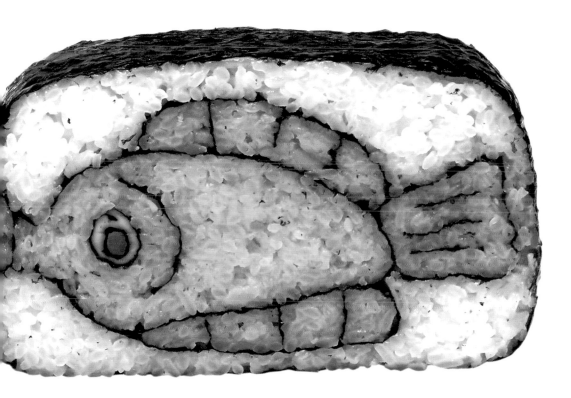

we're both males fighting for territory. Honestly, we are frustrated.

くちびるで突っつき合っているオス同士。実はイライラしてるんです。

やまおり Mountain fold

Kissing Gourami

Perciformes, Helostomatidae
(The only modern species in the
Helostomatidae family)
Habitat: Indonesia and the Malay
Peninsula
Length: Approximately 8 inches / 20cm

キッシンググラミー

スズキ目ヘロストマ科（ヘロストマ科唯一の現生種）
分布：インドネシア、マレー半島
全長：20cm ほど

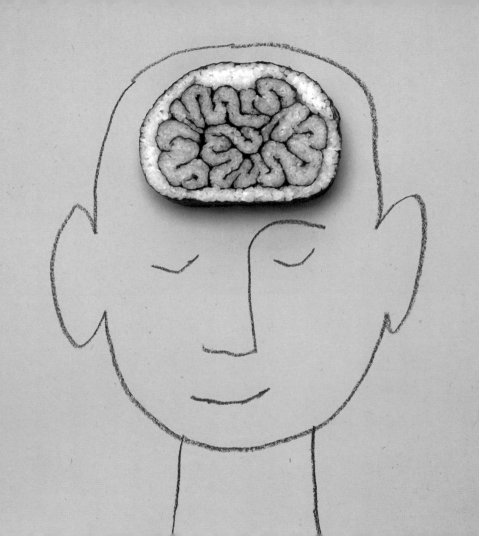

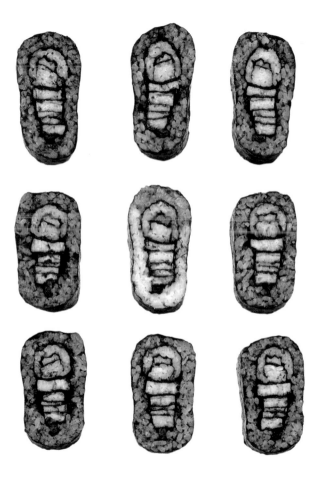

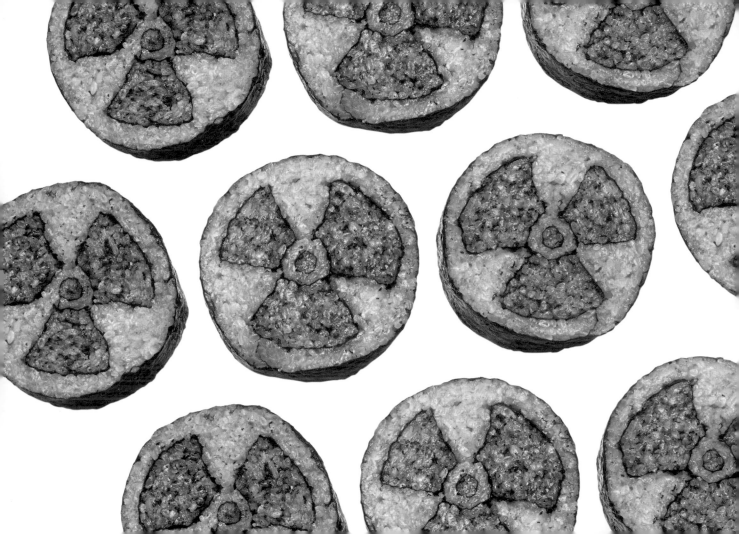

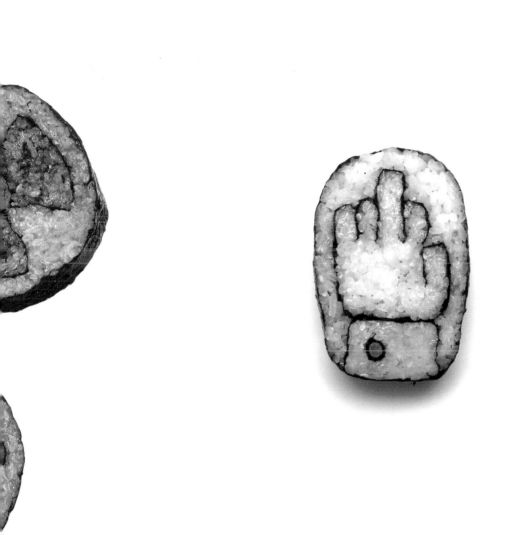

Family tree

Family Tree

My parents, my grandparents, and then I have great grandparents…
If you go back five generations, you realize that you are connected to
a huge number of people.

Our lives are the result of many meetings. I sometimes think about
that when I'm rolling sushi.

私の両親、両親それぞれの両親、またその両親のそれぞれの両親……
５代もさかのぼれば数えるのが大変な人数になる。
実際はその何百倍の出会いのおかげで自分の命が生まれたんだなって、そんなことを考
えながら巻くこともあるのです。

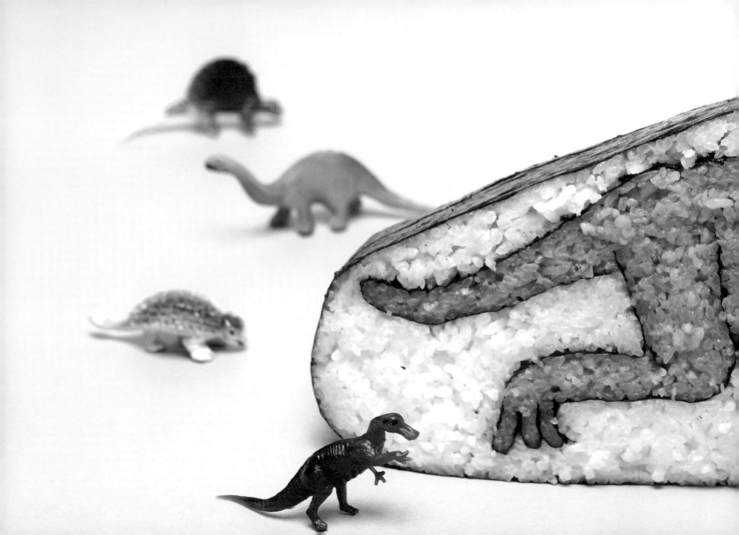

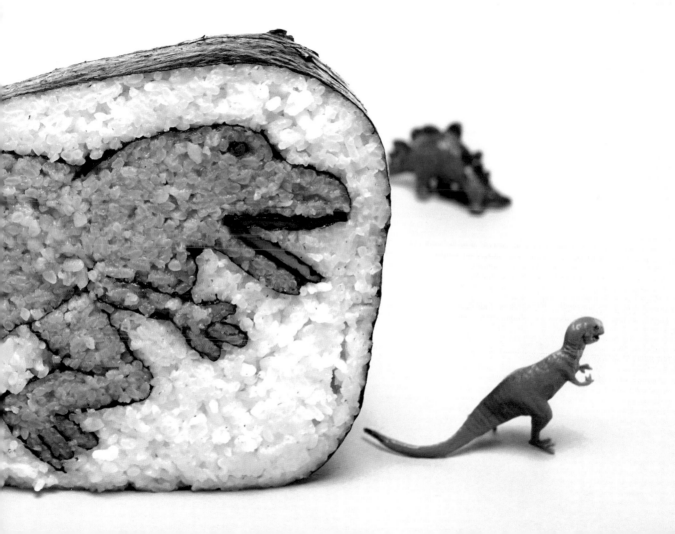

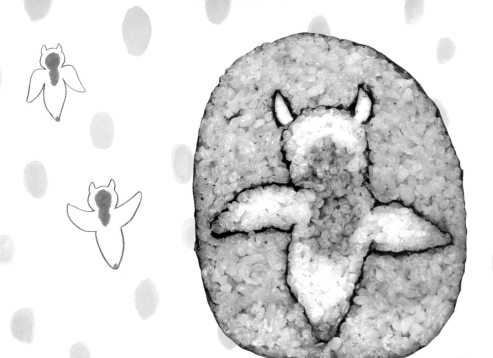

The Sea Angel and the Devil

If a good person sometimes behaves badly, we too easily think "that person is a bad person!" On the other hand, when a rude person is unexpectedly kind, we think "this person is a great person!" So, I don't usually mind what people think of me, even if they don't think I'm a good person.

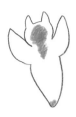

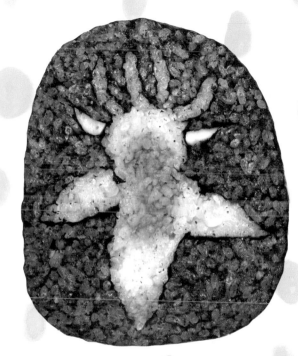

Clione

A fish in the family *Clionidae*.
The Clione turns carnivorous
as it grows. When it preys, the
head splits open and tentacles
called buccal cones appear.
The Clione absorbs nutrients
slowly through these cones as
it holds its prey.

流氷の天使と悪魔

普段いい人が、たまに意地悪かったりすると「本当は性格が悪いんだ！」と思われてしまいます。
逆に、ぶっきらぼうな人が意外に親切だったりすると「本当はいい人なんだ！」と株を上げたり。
だから私は、ふだんは「いい人」と思われなくてもいいと思っています。

クリオネ

ハダカカメガイ科。成長すると肉食に変化する。捕食時には頭が割れ、バッカルコーンと呼ばれる触手を伸ばし、エサを抱え込むようにしてゆっくりと養分を吸収する。

Hey! I am Mandrake! My root looks like a human being. I'm a mysterious plant.

I'm going to scream if you pull me out.

Once you hear my scream you will go insane and die. People have used me as a curse since early times.

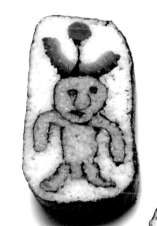

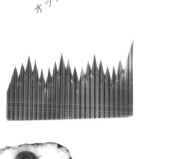

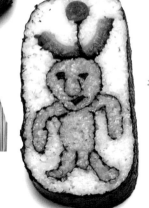

オッス！ おらマンドラゴラ！ 根っこが人間のかたちをしたなぞの植物さ。

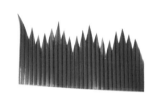

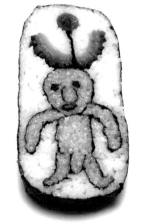

おらを引っこ抜くと、大きな声で叫ぶよ。

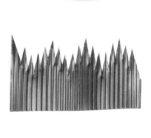

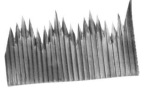

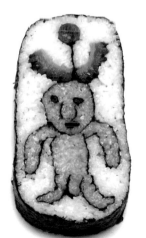

その声を聞いたら、みんな気が狂って死んでしまうのさ。昔から魔術なんかによく使われているんだよ。

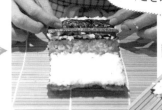
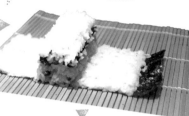

Making "My Lovely Kitten"
「こころのこねこ寿司」を作ったよ

When I make a sushi roll, I always think "I hope this roll will be like nothing anyone has ever seen before." I don't do a trial run even when I'm making a complicated design.

「誰も見たことがないものが作れたら」と思いながら、
どんな複雑なものでも練習せずに巻いてます。

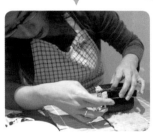

Let's roll the world through seaweed and rice!

ごはんとのりで
世界を巻くよ！

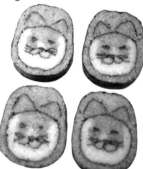

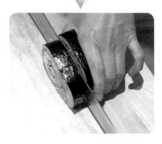

Each sushi slice is slightly different. These subtle differences are fun.

どこを切っても同じではなく、実はすこ〜しずつ違っ
ていて、その微妙な違いが楽しい。

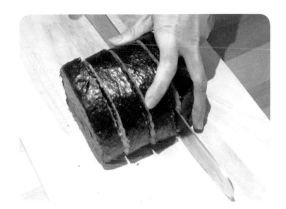
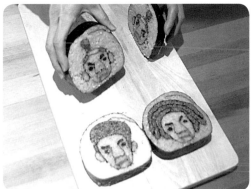

The changes in the shapes and colors of the creations in this book are not from different rolls, but from one complete roll with a lot of twists and turns inside. Different patterns emerge through changing the layout of the ingredients. It's exciting to see what will come out, as though I am turning the pages of a children's book. It's like telling a story.

この本でも紹介している色や形が変化する作品は、いくつも作っているのではなく、一本の巻き寿司の中で、具などの配置を変えているので、切るごとに違う絵が出てくるのです。絵本のページをめくるように、次になにが出てくるか、ストーリーが生まれるようでわくわくします。

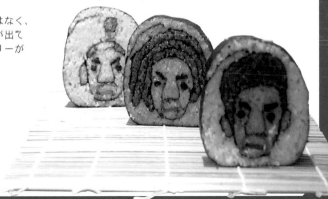

Workshop

When I hold a workshop, the participants are all hearing the same instructions and using the same ingredients, but they each complete a sushi roll in their own unique way. You don't know what patterns will appear, even though you're the one doing the rolling. Rolling expresses your unconscious feelings clearly. Can you hear the inner voice of each sushi roll?

ワークショップをするといつも思うのですが、同じ時間、同じ説明を聞き、同じ材料で
作っているのに、出来上がった作品（巻き寿司）は見事に人それぞれだということ。
手順は説明するけど、作業は個人の自由に任せています。
切ってみないと絵柄のバランスは誰にもわからない。
作っている本人にも。
だから、その人の無意識の感覚がハッキリ現れる。
巻き寿司から一人一人のつぶやきが聞こえてきそうじゃない？

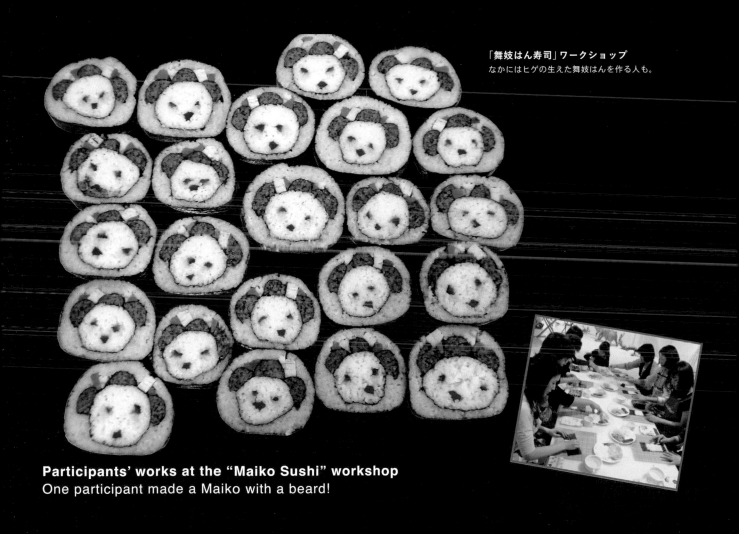

Participants' works at the "Maiko Sushi" workshop
One participant made a Maiko with a beard!

How to Prepare Sushi Rice

Although it is often referred to as glutinous or sticky rice, the rice most commonly eaten by the Japanese— *uruchi mai*—is non-glutinous. (The glutinous variety is known as *mochi gome*.) Short grain rice is readily available in supermarkets and usually includes the word "rose" in its name, e.g. "Japan Rose" or "California Rose," however it may simply be labeled "Japanese Rice." Uncooked Japanese rice, as with all other types of rice, should be stored in an airtight container at room temperature.

Ingredients

1¼ cups (250g) uncooked short-grain Japanese rice
Cold water to wash rice
3 in (8cm) square piece *konbu* (dried kelp)
1¼ cups (300ml) water
2 tablespoons vinegar
2 tablespoons sugar
1 teaspoon salt

Makes 2½ cups

1

Place the rice in a large bowl or saucepan and add enough cold water to cover. Stir the rice with your fingers for 1 minute until the water becomes quite cloudy. Drain in a colander and repeat the process 3 or 4 times until the water is almost clear. Drain in a colander and set aside for at least 1 hour.

2

Wipe the *konbu* with a damp cloth to remove any grit, but do not try to wipe off all the white powder. Using scissors, cut the *konbu* into 4 pieces.

3

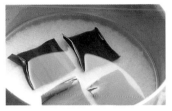

Place the rice in a heavy saucepan or rice cooker. Add the water and sake, and place the *konbu* pieces on top. Cook over medium heat and remove the *konbu* just before it reaches boiling point (otherwise the rice becomes slimy). When the broth reaches a rolling boil, reduce heat to low, cover the saucepan, and simmer for about 15 minutes, or until all the liquid is absorbed. Try not to lift the lid too many times to check this.

4

Remove from the heat and leave the rice to sit covered for 15 minutes. Then, using a wooden spoon or rice paddle, gently fluff up the rice. Place a kitchen towel over the saucepan and cover with the lid. Leave for 10 minutes to absorb excess moisture. Dissolve the sugar and salt in the vinegar in a small, non-metal bowl. Spread the rice out to dry in a large, non-metal container, about 30cm (12 in) across, and sprinkle the vinegar mixture over it.

5

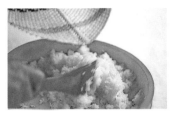

Fold the vinegared rice gently until all the vinegar has been incorporated. Then fan the rice lightly with a paper fan or a powered fan for about 5 minutes or so. This quick cooling process is essential to achieve the desired texture consistency and flavor of Sushi Rice.

6

Cover the container with a damp kitchen towel. The rice is now ready and can be kept at room temperature for up to 4 hours. Do not refrigerate the prepared Sushi Rice as this hardens and dries the grains. While the vinegared rice is still warm, portion it into glass or ceramic bowls before adding the colorizing ingredients, which could add unwanted colors or flavors to wooden or bamboo bowls. It's important to color the rice while it's still warm, as the colorizing ingredients may not blend well with overly-cooled rice.

Please note: "How To Prepare Sushi Rice" is reprinted from *Quick & Easy Sushi and Sashimi* by Susie Donald especially for the U.S. edition of this book. Photos © Periplus Editions (HK) Ltd

Let's Make "The Scream" Sushi!

こころの叫び寿司を
作ってみよう!!

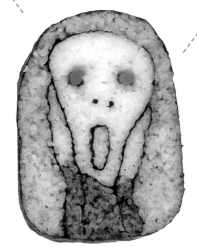

Measurements are given in imperial as well as metric.

1 large (12 x 12 inch / 30 x 30cm)
or two regular sized *makisu*
(bamboo rolling mat)

巻きす大 (30 × 30cm) 1枚
なければ普通の巻きす2枚

2 + ¼ Seaweed sheets

のり全形2枚と¼枚

Chopping
knife

包丁

Kitchen scissors

キッチンバサミ

Tomato sauce

Cling wrap

Cooked squid
ink pasta

Pickled *gobō*
(burdock root pickles)

山ごぼうの漬物

Akashiso furikake
(Red perilla powder)

赤しそのふりかけ

Black sesame seeds

黒ごま

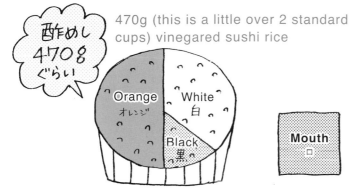

酢めし
470g
ぐらい

470g (this is a little over 2 standard cups) vinegared sushi rice

Orange
オレンジ

White
白

Black
黒

Mouth
口

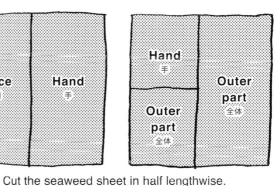

Face
顔

Hand
手

Hand
手

Outer
part
全体

Outer
part
全体

Cut the seaweed sheet in half lengthwise.

のりはタテ半分に切ったものを使う。

Color the vinegared rice while it's still warm. Mix in the tomato sauce to make some of the rice orange and the *akashiso furikake* and sesame seeds to make some of the rice black. See above for the percentage.

酢めしを作り、だいたい3:2:1の割合で分ける。
温かいうちに、トマトソース（オレンジ）、
赤しそのふりかけと黒ごま（黒）を混ぜる。

Wet your hands in order to handle the rice more easily.

手にごはんがくっつかないように、
手酢を使う。

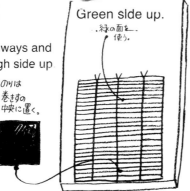

Green side up.

緑の面を
使う。

のりは
巻きすの
中央に置く。

Place the cutting board lengthways and lay the rolling mat on top, rough side up.

まな板はタテに置き、
巻きすをとじ糸が奥になるように置く。

Lay a seaweed sheet on the middle of the rolling mat.

Finger
bowl

Drop a bit of vinegar into a bowl of water.

手酢

水に酢を
少々入れる。

Hand
towel
手ぬぐい

Wipe excess water.

余分な水分を
ぬぐうため。

Cut!

Cut the pickled *gobō* the same length as the seaweed sheet.

山ごぼうは
のりの幅に合わせて切る。

1 Making the mouth 口を作る

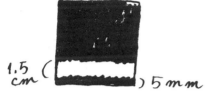

1.5 cm () 5 mm

Leave about a ¼ inch (5mm) of bare edge and spread the rice about ½ inch (1.5cm) wide.

手前 5 ミリほど残し、酢めし (白) を約 1.5 センチ置く。

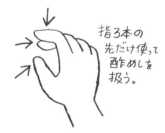

指3本の先だけ使って酢めしを扱う。

Use only three fingertips when handling the rice.

2 Making the face 顔を作る

Roll the seaweed sheet into an oval.

楕円になるように巻く。

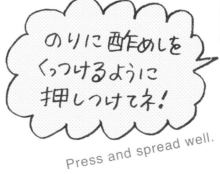

のりに酢めしをくっつけるように押しつけてネ！

Press and spread well.

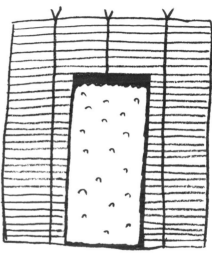

Place white rice in the middle of the seaweed sheet and spread, leaving ⅜ inch (1cm) of seaweed bare at the far edge.

巻きすの中央にのりを置き、端を 1 センチほど残して、酢めし (白) をまんべんなく置く。

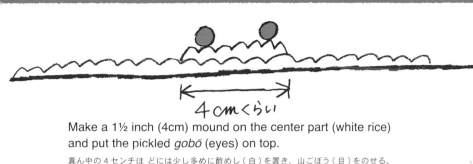

４cmくらい

Make a 1½ inch (4cm) mound on the center part (white rice) and put the pickled *gobō* (eyes) on top.

真ん中の４センチほ どには少し多めに酢めし（白）を置き、山ごぼう（目）をのせる。

顔を
逆さまに
作っていくよ!

The face is now on its head!

Fill the gap between the eyes with white rice, and add more above the eyes to cover.

目と目の間を酢めし（白）で埋め、目がかくれるように上にも置く。

Place 2 pieces of cooked squid ink pasta as nostrils, then fill the gap between them with white rice.

イカスミパスタ（鼻の穴）をのせ、その間を酢めし（白）で埋める。

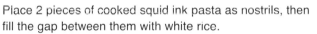

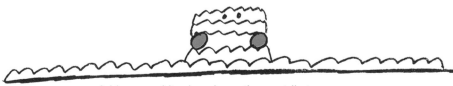

Add more white rice above the nostrils to cover.

鼻の穴がかくれるように、まわりに酢めし（白）を置く。

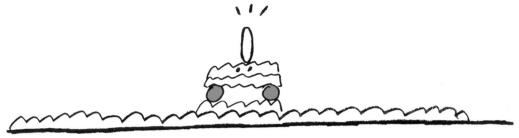

The mouth part that was made earlier will be placed on top.
Carefully pick up both sides of the mat and roll it up.
先に作った口のパーツをタテに置き、巻きすを持ち上げ、巻き上げる。

Place more white rice.
酢めしを補う。

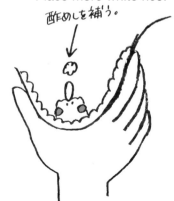

I important !!

Don't worry if the seaweed sheet is too short.
You can wet the seaweed and seal the roll.

のりが足らなくなっても
切ったのりをのせればくっつくから
慌てないでネ!

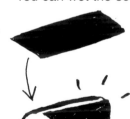

Overlap by ⅜ inch (1cm).

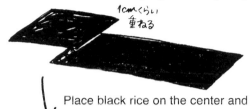

1cmくらい
重ねる

Apply a thin band of rice at one end to act as a paste when the two ends overlap.

タテ半分ののりと¼ののりを、ごはん粒を糊がわりにして貼り合わせる。

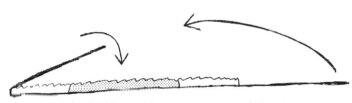

Place black rice on the center and white rice on both sides of it.

酢めし（黒）を中央に、両脇に（白）を置く。

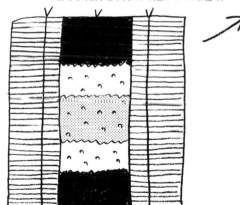

Fold both sides of the seaweed sheet.

のりの両端をパタンと折りたたむように重ねる。

Cut the middle of the sheet.

半分に
切る。

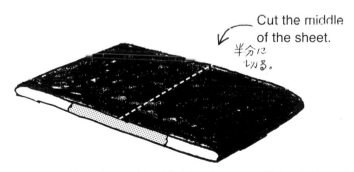

White rice about 1¼ inch (3.5cm)
Black rice about 2¼ inch (6cm)

（白）3.5cm（黒）6cm

Turn the sealed side face down, and let it sit for a while.

綴じ目を下にしてしばらく置く。

4 Roll the parts together 全体を巻く

Overlap by ⅜ inch (1cm).

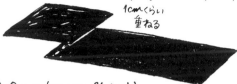

1cmくらい
重ねる

) 2cm (or app. ¾ inch)

Paste 2 seaweed sheets together with rice.
Place a generous amount of orange rice
and press well. Leave the center bare as
shown in the picture.

手の時と同じように 2 枚ののりを貼り合わせ、
酢めし (オレンジ) を図のように端と中央を残して置く。

) 5cm (or 2 inches)

Carefully attach the hands to both
sides of the face. Fill the gap between
the hands with black rice.

バランスをみながら、
手を顔の両脇に付け、
手と手の間に酢めし (黒)
を詰める。

Place the completed figure on the bare
center space on the seaweed sheet.
Lift up the entire mat and bring the
ends together into the center.

中央の空けておいたところに叫ぶ人を置き、
両側に酢めし (オレンジ) を多めに押し付け、
巻きすを持ち上げて一気に巻く。

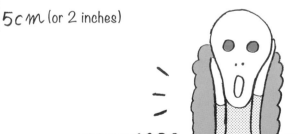

5 Cut 切る

Cover in cling wrap and shape it. Let it sit for a while.
Wet the knife and cut gently with a single motion.

巻き上がったらラップで包み端を整え、しばらく置く。
包丁を水でぬらして、やさしく押し引きしながら一気に切る。

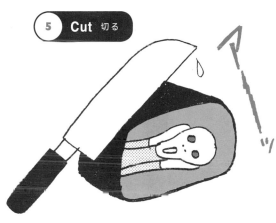

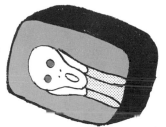

6 Done 完成

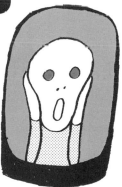

Let's enjoy 'The Scream'!

みんなで
こころの叫びを
楽しもう！

My Smiling Sushi Roll
collection from the past
思い出のにっこり寿司

Japanese Food

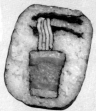

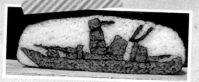

Gunkan-maki (Warship Roll)

Mt. Fuji on New Year's Day

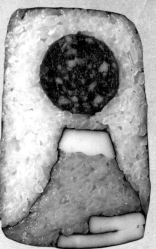

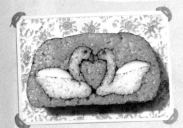

Swan's Heart

Memory of New York

Baby peanuts

Kokeshi Sisters

Madonna and Child

**The Kappa, water imp
and the ghost umbrella**

Voice

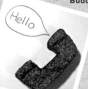

**Monk Kukai
and Sankosho
Buddhist object**

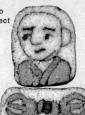

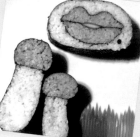

Lover's Night

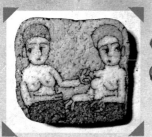

Gabrielle d'Estrées and
One of Her Sisters

Heart Flower

Mona Lisa

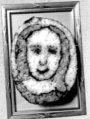

Tutankhamun

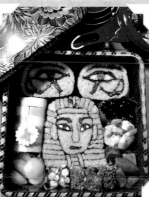

The Movie Character, Tora-san

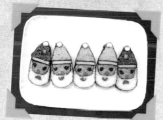

Evil Santa and Santa Claus

Johann Sebastian Bach

Coyote

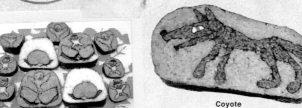

The Happiness of
Blue Birds

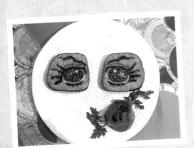

Manga Eyes

Barefoot Mermaid

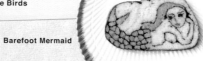

Coen° Workshop

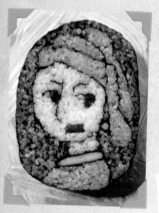

Girl with a Pearl Earring

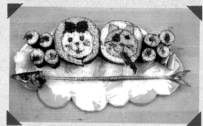

The Fish and Cat

Uncle Jari

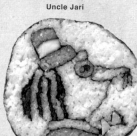

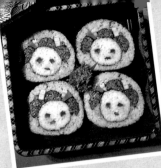

Maiko

Dedicated to Steve Jobs

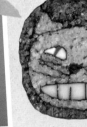

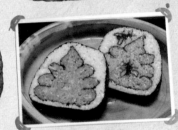

Cheshire Cat

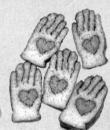

Poo and Flies

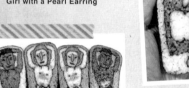

Naked Men

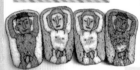

Heart in Hand

The Birth of Venus

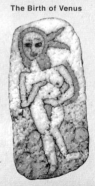

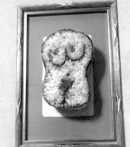

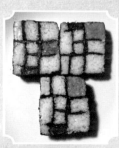

Naked Woman

Composition by Mondrian

Crane and Turtle

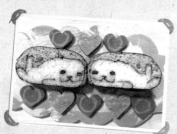
Lovely Seals, Goma-chan

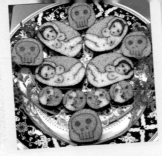
Dedicated to Guy Foissy

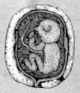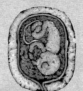
Birth

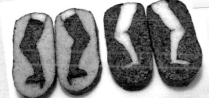
Sexy Legs

RAKKI

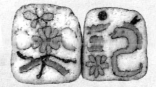

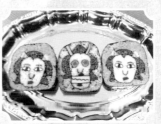
The Bunraku Puppet, Gabu

The Kohfukuji Temple Asura

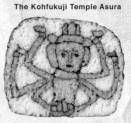

The Ryoanji Temple Garden

The Tohfukuji Temple Garden

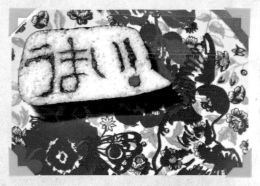
Delicious!

The Sushi Creations in This Book and Their Main Ingredients
作品タイトルとおもな材料

すべての作品に酢めしとのりが使われていますので、この2点は省いています。

"The Thinker"
by Auguste Rodin
ロダン「考える人」より

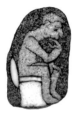

Kamaboko (fish paste loaf), basil sauce, black sesame seeds, akashiso furikake (red perilla powder), cucumber pickle.

かまぼこ、バジルソース、ごま、赤しそのふりかけ、きゅうりの漬物

"The Kiss" by Gustav Klimt
クリムト「接吻」より

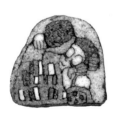

Kanpyō (dried gourd shavings), paprika, katsuobushi (dried tuna flakes), soy sauce, black sesame seeds, akashiso furikake (red perilla powder), pickled gobō (burdock root), carrot, kamaboko (fish paste loaf), omelet, aojiso (green shiso leaves), curry powder

かんぴょう、パプリカ、かつお節、ごま、赤しそのふりかけ、山ごぼうの漬物、にんじん、かまぼこ、玉子焼き、青じその漬物、カレー粉

"The Scream"
by Edvard Munch
ムンク「叫び」より

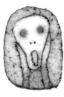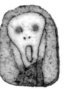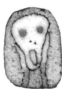

Tomato sauce, aojiso (green shiso leaves), pickled gobō (burdock root), cooked squid ink pasta, black sesame seeds, akashiso furikake (red perilla powder), blue food coloring

トマトソース、青じその漬物、山ごぼうの漬物、イカスミパスタ、ごま、赤しそのふりかけ、食紅（青）

"Sagrada Família"
by Antoni Gaudí
ガウディ「サグラダ・ファミリア」より

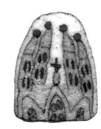

Curry powder, kanpyō (dried gourd shavings), black sesame seeds, akashiso furikake (red perilla powder), carrot, pickled gobō (burdock root), aojiso (green shiso leaves)

カレー粉、かんぴょう、ごま、赤しそのふりかけ、にんじん、山ごぼうの漬物、青じその漬物

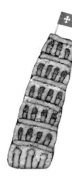

The Leaning Tower of Pisa
ピサの斜塔

Black sesame seeds, akashiso furikake (red perilla powder), kamaboko (fish paste loaf)

ごま、赤しそのふりかけ、かまぼこ

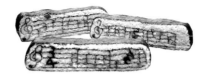

Happy Birthday

Kanpyō (dried gourd shavings), sakura denbu (pink flaked fish), black sesame seeds, curry powder, salami, pickled gobō (burdock root)

かんぴょう、桜でんぶ、ごま、カレー粉、サラミ、山ごぼうの漬物

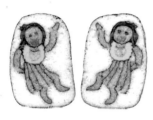

Aloha!
アロハ！

Date-maki (sweet rolled omelet), sakura denbu (pink flaked fish), aojiso (green shiso leaves), katsuobushi (dried tuna flakes), soy sauce

パプリカ、サラミ、かんぴょう、伊達巻き、桜でんぶ、青じその漬物、かつお節

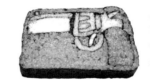

A Farewell to Guns
銃よ、さらば

Curry powder, kanpyō (dried gourd shavings), kamaboko (fish paste loaf), katsuobushi (dried tuna flakes), soy sauce

カレー粉、かんぴょう、かまぼこ、かつお節

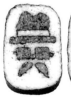
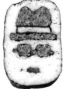

The Spy
スパイ

Black sesame seeds, akashiso furikake (red perilla powder), katsuobushi (dried tuna flakes), soy sauce, cooked squid ink pasta, paprika, omelet

ごま、赤しそのふりかけ、かつお節、イカスミパスタ、パプリカ、卵焼き

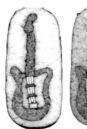
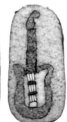

Songs from Your Lips ♪
唇に歌を♪（ギター）

Sakura denbu (pink flaked fish), red food coloring, slice of cheese, kanpyō (dried gourd shavings), kamaboko (fish paste loaf), akashiso furikake (red perilla powder), black sesame seeds, salami, curry powder

桜でんぶ、食紅（赤）、スライスチーズ、かんぴょう、かまぼこ、赤しそのふりかけ、ごま、サラミ、カレー粉

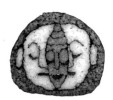

The Houshiwajo Standing Figure Face
「宝誌和尚立像」より

Curry powder, kanpyō (dried gourd shavings), black sesame seeds, akashiso furikake (red perilla powder)

カレー粉、かんぴょう、ごま、赤しそのふりかけ

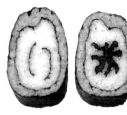

Rice
米

Salmon flakes, kanpyō (dried gourd shavings)

鮭フレーク、かんぴょう

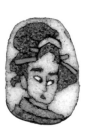

Ukiyo-e Portraying Beautiful Women
浮世絵美人

Omelet, cheese, akashiso furikake (red perilla powder), black sesame seeds, paprika, kanpyō (dried gourd shavings), sakura denbu (pink flaked fish), shibazuke (eggplant and cucumber pickled with red shizo)

玉子焼き、チーズ、赤しそのふりかけ、ごま、パプリカ、かんぴょう、桜でんぶ、しば漬け

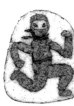

The Ninja
忍者

Curry powder, akashiso furikake (red perilla powder), black sesame seeds, kanpyō (dried gourd shavings), pickled gobō (burdock root)

カレー粉、赤しそのふりかけ、ごま、かんぴょう、山ごぼうの漬物

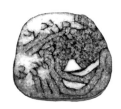

"The Great Wave off Kanagawa" by Hokusai
葛飾北斎「神奈川沖浪裏」より

Blue food coloring, omelet, kamaboko (fish paste loaf), black sesame seeds, akashiso furikake (red perilla powder)

食紅（青）、玉子焼き、かまぼこ、ごま、赤しそのふりかけ、ごま

The Japanese Salaryman
ジャパニーズ・サラリーマン

Black sesame seeds, akashi furikake (red perilla powder), kanpyō (dried gourd shavings), cheese, kamaboko (fish paste loaf), katsuobushi (dried tuna flakes), soy sauce, blue food coloring

ごま、赤しそのふりかけ、かんぴょう、チーズ、かまぼこ、かつお節、食紅（青）

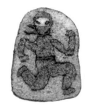

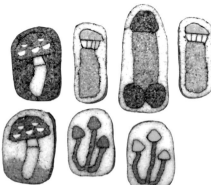

Don't Eat!!

Black sesame seeds, akashiso furikake (red perilla powder), salmon flakes, date-maki (sweet rolled omelet), katsuobushi (dried tuna flakes), soy sauce, kamaboko (fish paste loaf), bacon, curry powder, red and blue food coloring

ごま、赤しそのふりかけ、鮭フレーク、伊達巻き、かつお節、かまぼこ、ベーコン、カレー粉、食紅（青）（赤）、チーズ

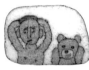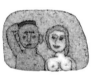

Pillow Talk
ピロートーク

Curry powder, salami, kanpyō (dried gourd shavings), dried squid, pickled ginger, cucumber, sakura denbu (pink flaked fish), black sesame seeds

カレー粉、サラミ、かんぴょう、スルメ、紅しょうが、きゅうりの古漬け、桜でんぶ、ごま

Bondage
緊縛

Kanpyō (dried gourd shavings), pickled ginger, cooked squid ink pasta

かんぴょう、紅しょうが、イカ墨パスタ

Completing Each Other
凸凹

Pickled ginger, katsuobushi (dried tuna flakes), soy sauce

紅しょうが、かつお節

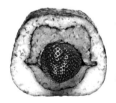

What do you suck?
あなたなら何をくわえる？

Sakura denbu (pink flaked fish)

桜でんぶ

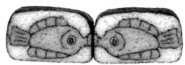

Kissing Gourami
キッシング・グラミー

Salmon flakes, pickled gobō
(burdock root), slice of cheese

鮭フレーク、山ごぼうの漬物、スライスチーズ

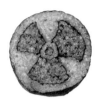

Imminent Danger
キケンは、すぐそばに

Black sesame seeds, akashiso
furikake (red perilla powder),
curry powder

ごま、赤しそのふりかけ、カレー粉

Oh no! "No" means brain in Japanese.
OH! 脳！

Salmon flakes

鮭フレーク

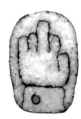

Fuck you!
手は口ほどにモノを言う

Sakura denbu (pink flaked fish),
salami

桜でんぶ、サラミ

One Percent Inspiration and Ninety-nine Percent Perspiration
1% のひらめきと 99% の努力

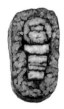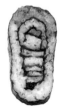

Omelet, kamaboko (fish paste
loaf), carrot, kanpyō (dried
gourd shavings), black sesame
seeds, akashiso furikake (red
perilla powder), curry powder

玉子焼き、かまぼこ、にんじん、かんぴょう、
ごま、赤しそのふりかけ、カレー粉

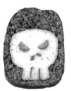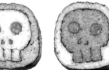

Family Tree

Sakura denbu (pink flaked fish),
salami, kamaboko (fish paste
loaf), curry powder, black sesame
seeds, akashiso furikake (red
perilla powder), salmon flakes

桜でんぶ、サラミ、かまぼこ、カレー粉、ごま、
赤しそのふりかけ、鮭フレーク

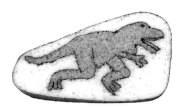

The Age of the Dinosaur
恐竜の時代

Tomato sauce, kanpyō (dried gourd shavings), kamaboko (fish paste loaf), black sesame seeds, akashiso furikake (red perilla powder)

トマトソース、かんぴょう、かまぼこ、ごま、赤しそのふりかけ

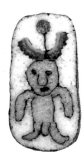

Mandrake
マンドラゴラ

Curry powder, kanpyō (dried gourd shavings), gōya (bitter melon), salami

カレー粉、かんぴょう、ゴーヤ、サラミ

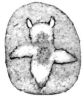
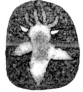

The Sea Angel and the Devil
流氷の天使と悪魔

Tomato sauce, black sesame seeds, akashiso furikake (red perilla powder), sakura denbu (pink flaked fish), kamaboko (fish paste loaf)

トマトソース、ごま、赤しそのふりかけ、桜でんぶ、かまぼこ

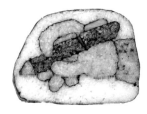

The Hand Holding a Pen
ペンを持つ手

Black sesame seeds, akashiso furikake (red perilla powder), cheese, curry powder, kanpyō (dried gourd shavings), aojiso (green shiso leaves), salmon flakes, carrot

ごま、赤しそのふりかけ、チーズ、カレー粉、かんぴょう、青じその漬物、鮭フレーク、にんじん

The basic ingredients of most Smiling Sushi Rolls are curry powder, cheese, kamaboko (fish paste loaf), sesame seeds, an omelet, tomato sauce, salami, along with vinegared rice and seaweed sheets.

Acknowledgement: Special thanks to Yoko Omine (Little More Co. Ltd.), Akane, 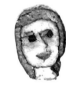 ATSUKOBAROUH , Inomoto Noriko, Otake Nobuo, CAF Vogue Ruby, Keihanshin Lmagazine, Siraishi Chieko, Sekine Toshiya, Seki Keiko, My Family (Father, Mother, Brother), Tsuzuki Kyoichi, "Mago No Chikara" (Kirakusha), Maruyama Hikaru, Morimoto Chie, Children of goen°, coen°, Matt Naiman, Yamamoto Toshiko, Yokoyama Takuya

協力：あかね、 ATSUKOBAROUH 、猪本典子、大竹伸朗、CAF Vogue Ruby、京阪神エルマガジン社、白石ちえこ、関根俊哉、関 敬子、父・母・兄、都築響一、「孫の力」（木楽舎刊）、丸山 光、森本千絵、goen°、coen° の子供たち、Matt Naiman、山元とし子、横山拓也（敬称略）

Published by Tuttle Publishing, an imprint of Periplus Editions (HK) Ltd.

www.tuttlepublishing.com

SMILING SUSHI ROLL
Copyright © 2014 by Tama-chan
English translation rights arranged with LITTLE MORE CO. LTD. through Japan UNI Agency, Inc. Tokyo
Translation copyright © 2016 by Tuttle Publishing

Art by Tama-chan
Book design by Yotsuba kakou
Photography by Toshihiko Sakagami
English translation by Hall Kyoko, Hall Tom
Editing by Yoko Omine

ISBN 978-0-8048-4667-7

18 17 16 15 5 4 3 2 1 1512TWP
Printed in Malaysia

Distributed by

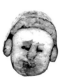

North America, Latin America & Europe
Tuttle Publishing
364 Innovation Drive
North Clarendon, VT 05759-9436 U.S.A.
Tel: 1 (802) 773-8930; Fax: 1 (802) 773-6993
info@tuttlepublishing.com; www.tuttlepublishing.com

Japan
Tuttle Publishing
Yaekari Building, 3rd Floor
5-4-12 Osaki, Shinagawa-ku
Tokyo 141 0032
Tel: (81) 3 5437-0171; Fax: (81) 3 5437-0755
sales@tuttle.co.jp; www.tuttle.co.jp

Asia Pacific
Berkeley Books Pte. Ltd.
61 Tai Seng Avenue #02-12
Singapore 534167
Tel: (65) 6280-1330; Fax: (65) 6280-6290
inquiries@periplus.com.sg; www.periplus.com

The Japanese specialty foods used to make the Smiling Sushi Rolls can be found in Asian grocery stores worldwide. Below are a few of the many online vendors of Asian food products.

US

Asian Food Grocer.com • www.asianfoodgrocer.com
BuyAsianFoods.com • www.buyasianfoods.com
HMart • www.hmart.com
Koamart • www.koamart.com
Marukai eStore • www.marukaiestore.com

UK

Japan Food Hall • http://japanfoodhall.com
Japanese Kitchen • www.japanesekitchen.com.uk
Oriental Mart • www.orientalmart.co.uk
Starry Oriental Foods • https://starryasianmarket.co.uk
The Asian Cookshop • www.theasiancookshop.co.uk

AUSTRALIA

Exoticgroceries.com.au • www.exoticgroceries.com.au
My Asian Grocer • www.myasiangrocer.com.au
Sunmart Japanese Groceries • www.sunmartgc.com.au
Umeya • www.umeya.com.au

ABOUT TUTTLE
"Books to Span the East and West"

Our core mission at Tuttle Publishing is to create books which bring people together one page at a time. Tuttle was founded in 1832 in the small New England town of Rutland, Vermont (USA). Our fundamental values remain as strong today as they were then—to publish best-in-class books informing the English-speaking world about the countries and peoples of Asia. The world has become a smaller place today and Asia's economic, cultural and political influence has expanded, yet the need for meaningful dialogue and information about this diverse region has never been greater. Since 1948, Tuttle has been a leader in publishing books on the cultures, arts, cuisines, languages and literatures of Asia. Our authors and photographers have won numerous awards and Tuttle has published thousands of books on subjects ranging from martial arts to paper crafts. We welcome you to explore the wealth of information available on Asia at **www.tuttlepublishing.com**.

The end